Plein Air Painting in Watercolor

by Scott Burdick

Walter Foster Publishing, Inc.
23062 La Cadena Drive
Laguna Hills, CA 92653
www.walterfoster.com

Contents

Introduction

En plein air is a French term meaning "outdoors," so painting *en plein air* simply means "painting outdoors." The reason painting from life is so important (especially for beginners) is that when you are working from a live subject, the colors and values you see are true—in other words, your subject is free from the distortions that occur in a photograph. As you gain some experience painting from life, you'll see what is missing from a photo and learn to compensate for it. Another benefit to painting outdoors is that you are automatically given a time limit—either because your subject moves or because the light is changing quickly. This forces you to simplify your composition and paint only what is absolutely essential. And in time, this knowledge will carry over into your studio paintings as well. Whenever I feel myself slowing down in the studio or starting to paint too tightly, I know it's time to get outdoors and revive my plein air painting skills!

Watercolor is a wonderful medium for painting spontaneously outdoors. Because water can be found almost anywhere, watercolors are perfectly portable for trips, even when backpacking. And you don't have to worry about protecting wet paintings or packing paint thinners or mediums, as you would with oil paint. In addition, watercolor's versatile nature allows you to apply it in so many different ways that you can render a variety of subjects. You can make thick, opaque strokes or thin, translucent washes, layer colors to make rich blends, and create a wide range of fascinating textures. My hope is that the lessons in this book will inspire you to take a journey outside the studio and explore the limitless opportunities that await you *en plein air!*

Tools and Materials

Visit any art store, and you'll see an amazing selection of watercolor paints, brushes, and other tools. It's tempting to purchase everything, but remember that when you're painting outdoors, you need to travel lightly. So choose carefully, and always buy the best materials you can afford. (You'll be happier with the better results good-quality products provide!) The basic materials I take with me for plein air watercolor painting are paper (watercolor boards, watercolor blocks, or just a simple sketchbook), two or three brushes, a palette with my paints, a container for water, paper towels, a #2 pencil, an easel, and sometimes a chair and an umbrella.

Setting Up

Depending on where I'm going, I have three basic setups for outdoor painting—from the smallest and most portable to the largest and most fully equipped. With the largest setup, I basically have all the materials I'd have if I were painting in the studio. Because of its size, I use this setup only if I'm painting near home and have the use of a car. If I'm traveling far, I often ship all my painting equipment ahead to the hotel or to the location where I'll be painting; that way I don't have to bother with extra suitcases.

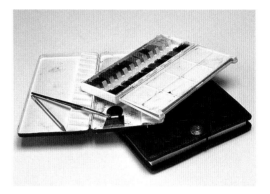

Simple Setup My smallest setup consists of my sketchbook and a fold-up palette, pan colors, a single brush, a pencil, a plastic water bottle, and a couple of paper towels. I use this setup mostly when I'm backpacking.

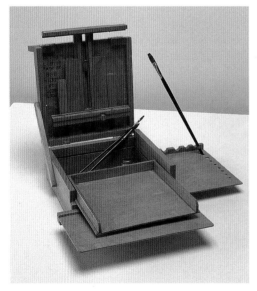

Travel Box A travel box can hold everything I need for small paintings. I set mine on my lap, but it can also be attached to a tripod so I can paint while standing. This setup also works well for traveling or painting in small spaces.

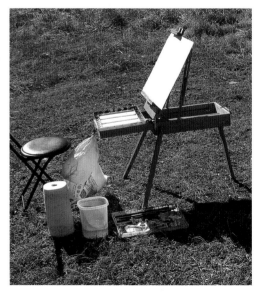

Large Setup My biggest setup is a full-color palette and a French easel. The easel can be adjusted to fit different board sizes. I carry all my supplies—including a complete set of brushes—in my backpack; the chair is optional.

Buying Paints

Watercolors come in tubes, cakes, and pans. I use all three varieties, depending on my setup and location. My basic outdoor palette consists of Chinese white, cadmium yellow light, cadmium lemon, yellow ochre, cadmium orange, cadmium red, permanent rose, alizarin crimson, cobalt violet, transparent oxide red, emerald green, sap green, viridian green, cobalt blue, ultramarine blue, and ivory black. These colors give me enough choices to mix almost any color I want, but you may need to purchase additional colors depending on your style and the subjects you decide to paint.

Palette This is the large studio palette that I also use in my French easel setup. I arrange my colors from cool on the left to warm on the right, plus white. It doesn't really matter how you arrange your colors, as long as you're consistent so your colors are easy to find each time you paint.

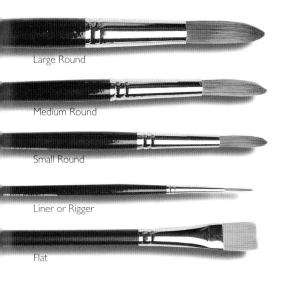

Large Round

Medium Round

Small Round

Liner or Rigger

Flat

Selecting Brushes

Although I prefer to use my old oil painting brushes, you will probably want to use watercolor brushes. You can purchase watercolor brushes in either natural or synthetic bristles. The five brushes shown at left make a good starter set. Use the large round for applying large areas of color. The medium round is good for thick or thin lines, depending on the pressure you apply. Choose the small round and liner brushes for details and the flat brush for laying in washes. The filbert bristle brushes I often use are made of a coarser hair, so they are good for creating textured strokes.

Choosing Papers

Watercolor paper varies by weight and texture. The higher the number is, the heaver and thicker the paper is. I prefer a heavier paper—at least 250-lb—that won't buckle under layers of wet paint (a plus when working outdoors!). Hot-press paper is smooth, whereas cold-press has some texture. Smooth papers are generally more absorbent than watercolor boards; this makes your painting appear softer, but it's harder to lift off color or soften dried paint. With watercolor boards, the paint lies closer to the surface, giving a crisper look. And you can easily lift off paint, even after it is dry.

Paper Textures You should choose the type of paper you use based on how much texture you want your final painting to have. From left to right are samples of how watercolor appears on rough, cold-press, and hot-press papers.

Color Theory and Mixing

Color is one of the most important aspects of any painting, but it is especially important when you're painting outdoors, trying to render a subject accurately. And because you'll be traveling with a fairly limited color palette, you'll need to learn to mix colors so you can replicate all the wonderful hues you see in nature. I have included some basic information here to get you started, but for further information see *Mix Your Own Watercolors* (AL27) in Walter Foster's Artist's Library series.

Color Basics

Some basic knowledge about color will go a long way when it comes to mixing your own colors. The *primary colors* (red, yellow, and blue) are the three basic colors that can't be created by mixing other colors. All other colors are derived from these three. Each combination of two primaries results in a *secondary color* (purple, green, or orange), and a combination of a primary color and a secondary color results in a *tertiary color* (such as yellow-orange or red-purple). On a color wheel, shown at right, the colors directly across from one another are *complementary colors*, and groups of adjacent colors are *analogous colors*.

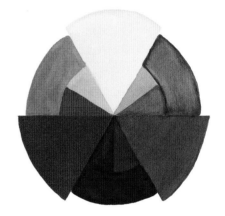

Color Wheel This diagram is a convenient visual reference for mixing color. Knowing how colors relate to and interact with one another will help you choose, mix, and use colors effectively.

Color Psychology

Colors are often classified in terms of "temperature." The "warm" colors are reds, oranges, and yellows, and the "cool" colors are greens, blues, and purples. But there are variations in temperature within every family of color, or *hue,* as well. For example, a red that contains more yellow, such as cadmium red, is warmer than a red that contains more blue, such as alizarin crimson. For plein air painting, remember that morning and evening colors are usually cooler than midday and afternoon colors. And late afternoon and sunset colors are the warmest. Similarly, autumn and summer scenes usually require warmer colors than winter and spring scenes do.

Vivid Secondary Colors For vibrant secondary colors, mix two primaries that have the same "temperature" (i.e., two cools or two warms).

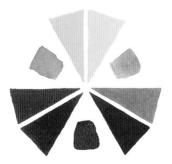

Muted Secondary Colors To create muted, subdued secondaries, mix two primaries of opposite "temperatures" (i.e., a warm with a cool).

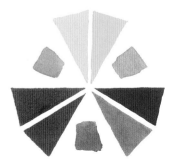

Seeing Complements

Complementary colors appear together in nature more often than you might think: for example, red berries among green leaves, a setting orange sun against a blue sky, or the yellow center of a purple iris. Sometimes if you look closely, you can observe more subtle complementary combinations in nature as well—for instance, white clouds in a blue sky often contain a slight hint of orange.

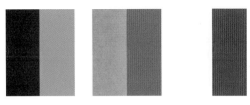

Complementary Colors When viewed next to each other, complementary pairs (e.g., red and green, orange and blue, and yellow and purple) can create lively, exciting contrasts.

Mixing Neutrals

Learning to mix neutrals is important because most colors you see in nature are more subtle and muted than the pure colors that come straight from a tube. The best way to neutralize, or *gray*, a pure color is to mix in a touch of its complement. And to create a natural, neutral gray (rather than using gray from a tube), simply combine equal amounts of two complements.

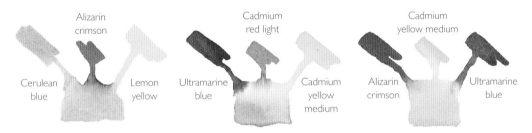

Mixing the Three Primaries When you mix three primaries, varying the quantity of each, you'll find that you can create a wide range of fresh browns and gray, as shown in the examples above.

Values in Watercolor

Value is the relative lightness or darkness of a color (or of black), and it is variations in value that create the illusion of depth and form in a painting. With opaque media, like oil paint, you lighten the value of your colors by adding white, and you generally begin with your darks and build up the lights. But with watercolor, you lighten the values by adding more water (the lightest value being white of the paper), and you usually start with the lightest values and build up your darks.

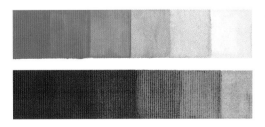

Value Scale The *value scales* shown above illustrate the range of values you can achieve just by adding water to the pigment. (Notice that these scales don't show all the light values possible.) The pure pigment is on the left, and more water is gradually added for successively lighter values.

Watercolor Techniques

Technique is individual to each artist—the way you manipulate your brush will become as unique as your own signature. And while some techniques might lend themselves to painting certain objects, you don't want to "formulize" the way you paint. The most exciting thing about painting outdoors is taking a realistic scene and painting it in an interesting way that makes it your own. Brushstrokes and the many techniques you use to create them can be beautiful in their own right. But if you can learn to combine that beauty with accurate drawing, values, color, and edges, then you will have a painting that succeeds on all levels. Once you understand how to use the basic techniques on these pages, you'll be amazed at how easy it is to create beautiful plein air paintings.

Basic Techniques

Wet-Into-Wet When you apply wet paint to a wet surface—called "wet-into-wet"—you can let the colors softly blend into each other. This is a good technique for rendering skies, water, glass, or anything with very soft edges.

Drybrushing Drag a dry brush with paint over the dry surface so that only the raised part of the paper receives the paint. This technique is great for naturally rough surfaces like rocks and grass textures.

Glazing For a transparent glaze, place a wash of color over an area that has already dried. Notice how the colors change where the glazed colors overlap. Glazes are especially useful when rendering shadows and reflections.

Lifting Out To reveal light areas, lift out color. Use a clean, stiff brush moistened with water and rub away the paint from a dry area of the painting. This technique works well for softening edges, adding highlights, and fixing mistakes.

Grasses

Lifting Out I use a variety of techniques to render different types of grasses. Here I use the lifting out technique to render blades of grass. With a small round watercolor brush moistened with water, I make several upward strokes on the dry green background and then dab out the color with a paper towel.

Splattering Here I just loaded a brush with a soupy mix of paint and water and splattered the paint with an upward motion to create the natural, random feel and shape of the grass. Other ways you can randomly apply specks of color to your canvas include flicking thinned paint off the tip of your brush, running your thumb against an old toothbrush loaded with paint, or tapping a loaded flat brush against your finger.

Drybrushing Drybrushing is great for detail work and creating the look of natural textures like this grass. Here I simply drybrush strokes of green with a small round watercolor brush onto dry paper to create tight, precise strokes. Even when painting something as simple as grass, I generally combine several of these techniques to create the most realistic rendering.

Trees

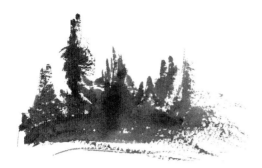

Suggesting Mass In this example, I use the drybrush technique and a small filbert bristle brush to suggest the shapes of a group of trees. The ragged edges I create are perfect for giving the impression of the many leaves of these trees without having to paint each one individually.

Rendering Leaves Here I apply some quick splatters to suggest the leaves—this is much faster and more interesting than painting each leaf individually. The tree branches put the splatters into context; when viewed together, the mind registers the splatters as leaves.

Adding Definition Here I use the lifting out technique to remove some color from the larger shapes to suggest the trunks of the trees. Details such as these are very difficult to try to paint around; instead of painting the trunks, I simply lift them out.

Clouds

Wet-Into-Wet Clouds For these clouds, I wet the paper with water and then paint the blue sky around the clouds wet-into-wet, allowing the paint to flow and create soft edges.

Lifting Out Clouds Here I create the soft edges of the clouds by rubbing out a dry blue background with a paper towel and some clean water.

Figures

Painting Simply Here I use a small round brush and just three colors to create some simple shapes that suggest two people walking. The fewer strokes you use, the more powerful your brush technique will become.

Conserving Brushstrokes Focus on breaking down what you see into basic shapes. This simple boat and figure in silhouette shows how just a few well-placed brushstrokes can create a believable figure.

Water

Showing Movement In this case, I use the lifting out technique to suggest a twisting river. I paint in the larger shapes first and let them dry. Then I use clean water and a filbert bristle brush to scrub out the serpentine pattern in the river.

Rocks

Showing Texture For these jagged rocks, I start by dry-brushing the underlying ragged shapes. Then I use more paint and hard-edged strokes for the cracks and surrounding edges. It's far more difficult to paint the cracks first and then try to paint around them!

Focusing on Drawing

Most successful paintings start with a good drawing to establish the basic shapes and patterns of the composition. When approaching your drawing, try not to think about rendering the object as a whole; instead, concentrate on just one abstract line, curve, or angle at a time. For example, don't think about drawing "a boat"; just draw the lines you see—a curve for the bow, perpendicular lines for the cabin, and a rectangle for the stern. When painting *en plein air,* I take a little more care with my drawing than I would in the studio, where I know my subject (such as a photograph or a model) will always be available. On location, I always draw the focal point of my painting (the boat in this lesson) right away. Then if the subject moves or leaves altogether, I'm still able to finish the painting.

Step One I make a preliminary sketch by lightly drawing the boat and buildings with a #2 pencil on a cold-press watercolor board. This sketch establishes the main shapes and the relationships among the shapes in the composition. Be conscious of the quickly changing nature of the outdoors, like the light at this time of day and how high the boat sits in the water.

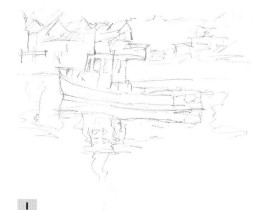

1

Step Two I begin painting by applying washes to the lightest areas using a mix of yellow ochre, burnt sienna, and a touch of ivory black. Although watercolor allows your drawing to remain visible beneath your washes, avoid the temptation to paint inside all the drawn edges, as if it were a "paint-by-number" painting. Always begin by painting the largest shapes first, then the medium shapes, and then the smallest shapes and details. Don't worry if your washes become too opaque and you can't see your drawing; you can always draw over it again as you work.

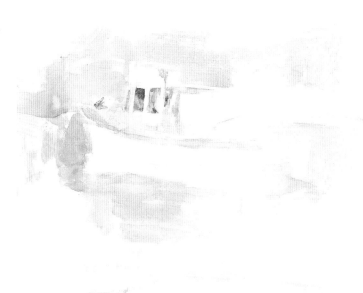

2

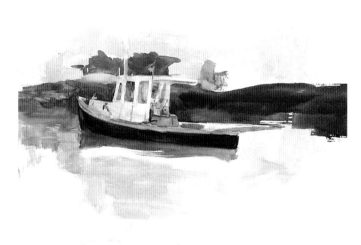

Step Three Next I block in some of the dark areas of the shoreline and the side of the boat with a mix of burnt sienna cooled with a touch of ultramarine blue. For these large shapes, I paint wet-into-wet, allowing the colors and values to mix themselves and form interesting patterns. Once these areas are dry, I add details to create sharper edges, especially inside the cabin of the boat. I define the upper edge of the cabin by painting olive green and burnt sienna above it. To its right, I add touches of diluted cadmium red medium and cadmium orange as a base for one of the buildings.

3

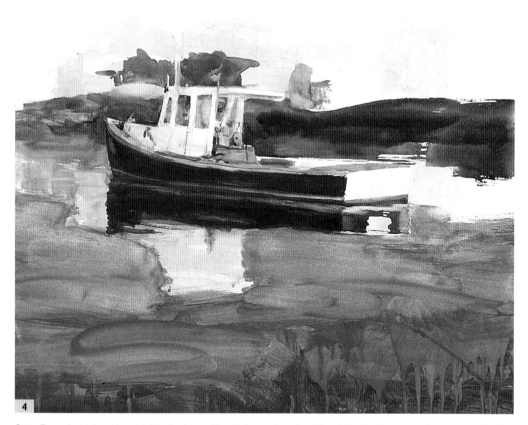

4

Step Four I add the stripe detail to the boat with cadmium red medium. Then I block in the water using large, bold strokes of cobalt blue and ultramarine blue that sweep horizontally across the entire area. For variety, I add touches of permanent rose and viridian green. As I do with most of the large areas of the painting, I use a medium flat and filbert bristle brushes. Even though these brushes are generally used for oil painting, I like the way the heavy bristles create streaks on the paper. For added interest, I also tilt the board vertically as it dries, allowing some of the paint to drip down at the bottom.

Step Five After everything is dry, I begin painting all the reflections. I add a few spots of pure cadmium red medium and cadmium orange in the reflection of the cabin to contrast sharply with the blues and greens and to draw in the viewer's eye. I continue refining the boat with a small round brush—I use a mix of cadmium yellow light and cadmium orange to create the plate on the back end and continue refining the stripe detail on the side with cadmium red medium. Next I block in some of the background trees, along with their corresponding reflections in the water. For the warm, sunlit values, I use a mix of viridian green, burnt sienna, and alizarin crimson.

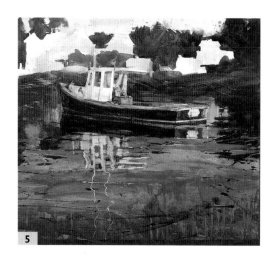

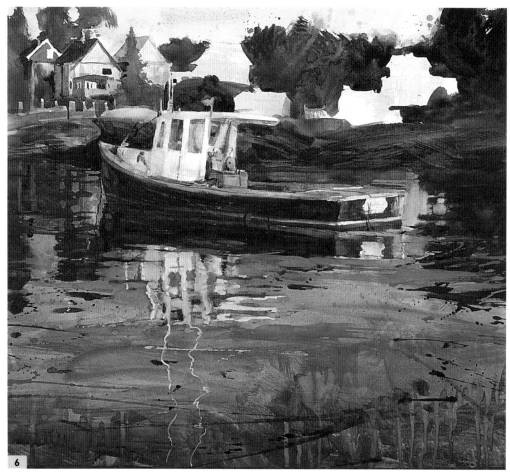

Step Six Now I start refining the shoreline with some dark mixes of black and burnt sienna. Using a small round brush, I carefully define some of the shapes of the houses on the left side with cadmium red medium, burnt sienna, and yellow ochre, with a touch of ultramarine blue for the cool shadows. Even with a well-thought-out preliminary drawing, every brushstroke requires careful placement. Always check the position of what you are about to paint against the other objects in your composition to make sure your brushstrokes are all in the right place.

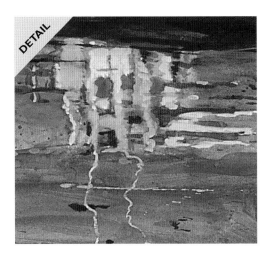

DETAIL

Reflection Detail For the reflections, I paint the delicate ribbons of light from the antenna with a bit of opaque white and yellow ochre, rather than trying to paint around the lights. If I'm painting a small light surrounded by a large dark area, I paint the dark shape first, and then I use opaque white for the highlight; if the light is the larger area, I paint it transparently first, and then I add the dark colors on top.

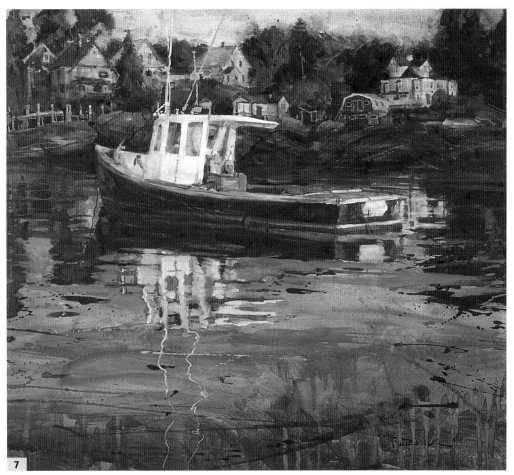

7

Step Seven I finish the houses and the background trees with less intense colors and values and softer edges, so they don't compete with the boat as the center of interest. Using small round and flat watercolor brushes, I apply viridian green, burnt sienna, and yellow ochre; I use cadmium red medium for all the brightly colored houses in the background. At this point, I also rework the areas I've previously painted, softening an edge or brightening a color—and the final result is a composition that's balanced and cohesive—and a believable rendering of a boat.

Determining Value

When painting from life, you'll find that the colors you see will have many more values than the limited range of colors on your palette. For example, in this peaceful bay, the white clouds were much lighter than the white of my paper, and the deepest shadows in the land masses were far darker than my darkest pigments. But all you need to do is determine the correct relationships among the values; that is, use the lightest lights and darkest darks as the extremes, and mix the middle values according to how much lighter or darker each is compared with the extremes in the subject. To do this, look at your subject and squint slightly. This minimizes the details and lets you focus on the range of values. Quickly glance back and forth between the subject's lightest and darkest values and the color you're trying to mix; try to determine where it falls in the range between the two extremes. How much lighter or darker is it? Then choose the colors from your palette that match the relative values you see, and your painting will be a success.

Step One First I wet the entire cold-press watercolor board with clean water, so that my edges will stay soft. Then, using a large filbert bristle brush, I block in the clouds (the lightest values of the painting) with a pale mixture of cerulean blue and permanent rose, with touches of viridian green and cadmium lemon. When painting clouds outdoors, I wait until I see a group of clouds that are particularly interesting; then I quickly draw their shapes and paint them before they change too much. You don't always have to paint the clouds first; just paint them when they look the best to you.

Step Two Using the same brush, I paint the negative shapes (the shapes between the clouds) with cerulean blue and a touch of viridian green. Switching to a large flat brush, I mix Payne's gray and permanent rose to strengthen the value of the shadowed underside of the clouds. When this is dry, I use clean water and a medium filbert bristle brush to scrub out a few highlights. I make sure to continually squint and compare these values to the darks on the ground—this keeps me from making the sky and the shadows of the clouds too dark.

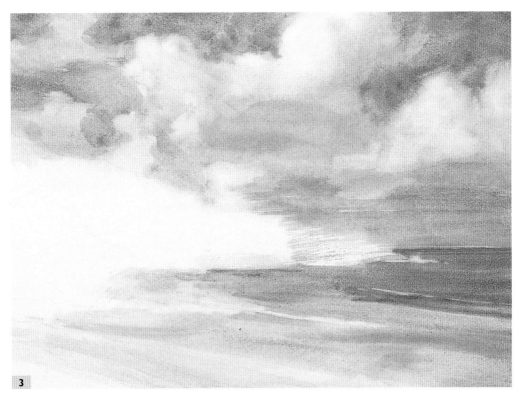

Step Three Now I switch to a medium flat brush to block in the water with mixes of cerulean blue, cobalt turquoise, permanent rose, and a bit of cadmium lemon. I also slightly darken the value of the sky near the horizon line to create some contrast at the edge of the water. Remember: Since there are no dark values on the paper at this point in the painting, you should mix most of your colors by looking at the full range of values on your palette. I step back periodically and look at the total range of values to make sure everything falls correctly between the lightest and darkest extremes.

Step Four Next I block in the hills with a small flat bristle brush using burnt sienna, permanent rose, Hooker's green, and some Payne's gray in the foreground sand. When I squint at my outdoor scene and study these values, I can see that nothing in the hills is as light as even the darkest darks in the sky. If my eyes were open and staring directly at the hills, I would be fooled into misjudging some of the lighter values in the land.

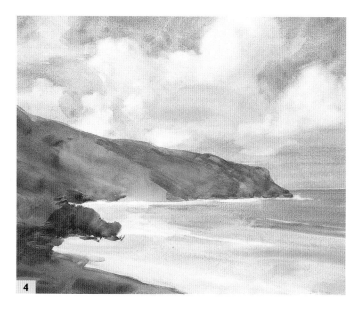

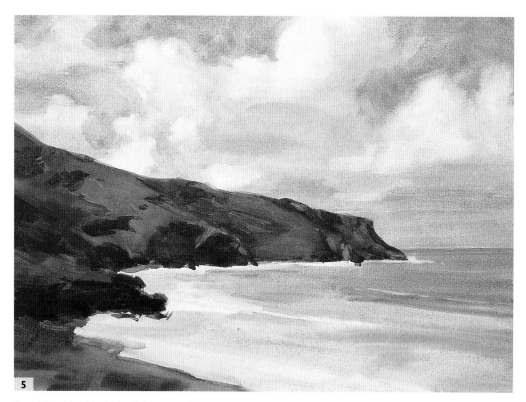

Step Five Next I lay in the darker areas of the hills, concentrating on the rocks in the lower left corner and on those near the shoreline. For this step, I use mostly mixes of burnt sienna, ultramarine blue, and viridian green. For the more detailed areas, I use a small filbert bristle and a small flat brush.

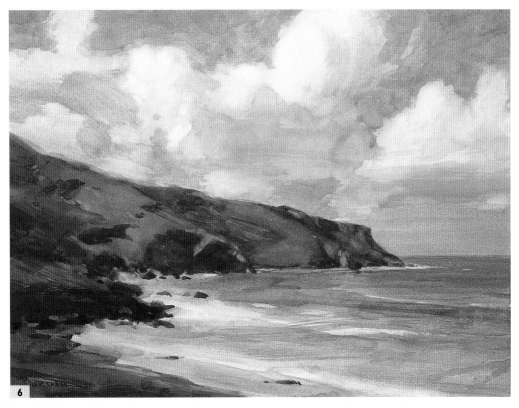

Step Six For my final steps, I use a medium flat brush to strengthen the values of the water with ultramarine blue, cerulean blue, and permanent rose; I also add cerulean blue and alizarin crimson washes to the sky. Then I apply a bit more Payne's gray to tie the shadows of the clouds together. At this point, I look carefully at the painting, refining the forms and softening a few edges (mostly along the upper edge of the hills), adding more detail where needed.

Rocks Detail My darkest dark is the shadowed area of the rocks in the lower left quadrant. This area—and the lightest light of the clouds—are the two places in my painting that I use to compare all the other values in the scene.

Water Detail I'm careful to retain the lighter values near the shoreline that suggest the breaking waves. The lightest values in the foamy water are just slightly darker than those used in the lightest areas of the clouds.

Recognizing Shapes

There are two ways to paint plein air portraits: One is to choose a subject that won't move much, such as a patron in a sidewalk café; the other is to hire a model, as I did for this painting. Once you have a subject to paint, you must train your eye to really "see" in terms of the abstract patterns or shapes that make up the human face. Think of the face as an arrangement of simple puzzle pieces, each with distinct shapes that form a precise pattern. Then you'll learn to paint what you really see, not your preconceived idea of what the subject should look like. To help you see the true shapes, squint your eyes slightly as you study your subject to help blur the subtle details into their larger patterns, such as the light triangle of the nose or the dark ovals of the eyes in this painting. And always begin by painting the largest shapes, such as the oval face in this portrait; then work down to the smallest shapes and details of the features last. Practice this technique, and soon you will find there is no difference between painting an outdoor portrait, a landscape, or any other subject.

1

2

Step One I start my initial pencil drawing on a cold-press watercolor board. Because I am painting a likeness, I am especially careful to accurately observe and copy the basic shapes and measure all the vertical and horizontal alignments. For example, I measure the distance between the eyes and the distance from the eyes to the nose. I also note how far the ears and mouth are from the nose. The key to successful portraiture is learning to recognize and depict the subtle differences in the features of each individual.

Step Two With a large filbert bristle, I wash the entire board with a light mixture of Payne's gray and yellow ochre to tone down the bright white of the paper. Then I block in the oval shape of the entire face (the largest shape) with diluted burnt sienna and cerulean blue. I suggest the background with some viridian green, raw sienna, and a touch of cadmium yellow light. Painting a portrait *en plein air* allows you to capture all of the fantastic colors from outdoor surfaces (such as trees and sky) that reflect on the face; you can't get this same effect from studio lighting.

Step Three Next I paint the eyes; these medium-sized oval shapes are my center of interest, so I paint them completely in this step. While squinting, I note how the eyebrow pattern on her right eye sweeps around and connects directly into the shadow of the forehead. The pattern continues down into the eyelids and eyeball and finally ends at the inside corner of the eye. With a medium filbert bristle, I block in this entire shape with burnt sienna, raw sienna, and a touch of Payne's gray. I also block in the larger shape of the left eye. I finish the eyes with a small flat brush and a round detail brush for the smallest details, using different values of the same colors as above, plus some alizarin crimson for the darkest accents.

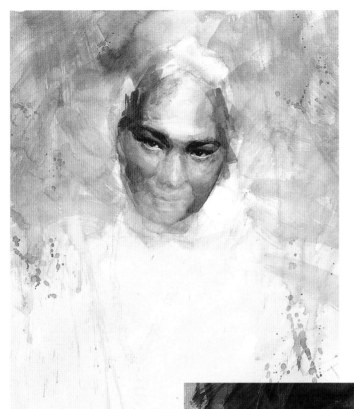

3

Step Four Using the same procedure, colors, and brushes, I paint one abstract shape after another—from the dark shape under the nose and the shape under the upper and lower lips to the shadow on the model's right side. (Notice how it connects to the neck and under the chin.) I try not to stare too long into any one area, and I make sure I don't paint any lines that are not visible while I'm squinting at my subject. For the hair and background, I use a large filbert bristle with a mix of burnt sienna and Payne's gray. Notice that I tie the dark values of the upper background into the hair and the shadowed side of the face and then eventually into the shirt. This creates a frame around the face and an interesting design. Without some dark values in the background, too much attention would be drawn to the uninterrupted curve at the top of the head.

4

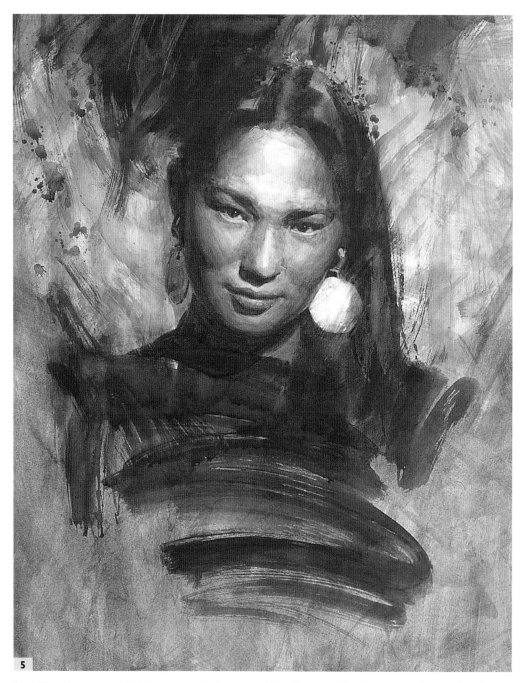

5

Step Five Using a large flat bristle brush, I paint the model's shirt with a mix of Payne's gray, burnt sienna, and cerulean blue. First I wash the entire area with a muddy undertone—this keeps the loose strokes of the shirt from contrasting too much with the light background and drawing attention away from the face. Then, using the same brush and a mix of Payne's gray and cerulean blue, I wash in the dark values of the shirt with a few simple, horizontal strokes. Now that the large shapes are blocked in, I continue refining the face, hair, earrings, and background.

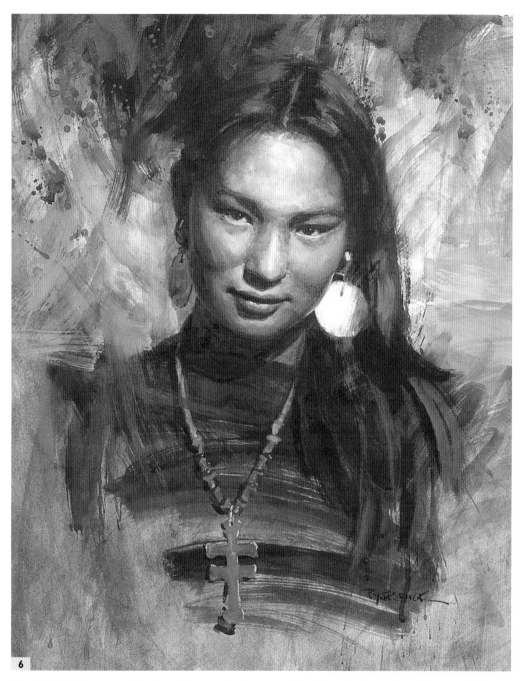

6

Step Six To finish my portrait, I refine the forms and soften some edges; I also add a few washes of clear water (with a large flat brush) over the cheeks and forehead to blend some of the large shapes together. For the highlights in the hair, I mix touches of cerulean blue and alizarin crimson with some white. For the necklace, I use a small flat brush, a round detail brush, and most of the colors on my palette, with some added white for the opaque highlights. To prevent the necklace from competing with my center of interest, I'm careful to keep the contrast and detail to a minimum.

23

Painting Edges

The secret to capturing the true essence of an outdoor scene on watercolor paper is to follow some "rules" regarding hard and soft edges. The first and most obvious rule is that harder surfaces have harder edges; for example, a building has harder edges than a cloud. Edges also appear harder on objects that are closer to you, so objects in the foreground will have harder edges than objects in the background. Moreover, when two shapes overlap (such as one branch of a tree crossing in front of another branch), the edges of the one in front will appear harder than the edges of the one behind. Another important rule is that an edge will always be harder on a plane that is more perpendicular to the light; for example, if the light is coming from above, the edges of the roof of a building will appear harder than the edges of the building's sides. In addition, the edges of a cast shadow become softer the farther away the shadow gets from the object casting it. Sometimes you can apply more than one of these rules to an object, such as the hard edges of the building in this painting; it's a hard surface and is close to the viewer, so it has relatively hard edges. When painting edges, the first thing you need to do is identify your extremes (the hardest and softest forms); then compare all the intermediate forms with them. Of course, there may be times when you decide to adjust an edge simply for artistic reasons, whether it be for variety or to emphasize your center of interest. In these instances, using *artistic license* is what will make your work unique.

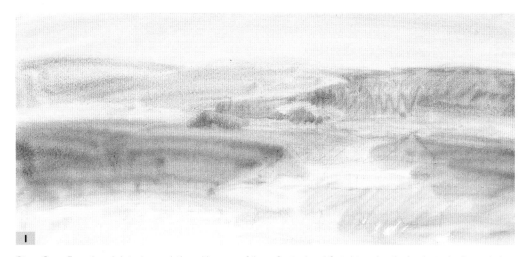

Step One Even though I start my painting with some of the softest edges, I first determine the hardest edge by squinting and looking across the entire scene—in this case, the hardest edge is the right edge of the barn's roof against the lighter background. (You don't have to paint this immediately; just compare the other edges in the scene to this extreme before painting them.) With a large flat bristle brush, I wet the board with clean water. Then I wash in some of the larger background shapes with cerulean blue, cobalt violet, and cadmium red medium, mixing in the red in varying proportions.

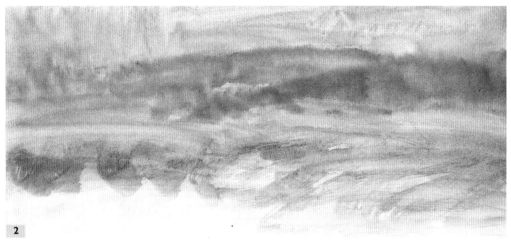

Step Two Still using the large flat bristle brush, I wash in cobalt violet over the upper portion of the painting and then work in some cobalt blue and cerulean blue. I tip the board vertically and rotate it every few seconds so the colors flow together.

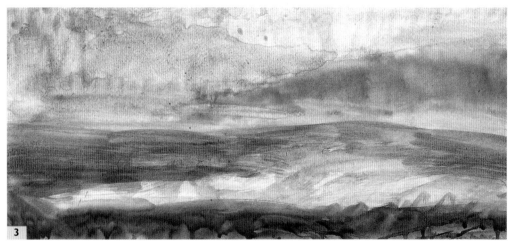

Step Three With a large filbert bristle brush, I block in the middle hills with mixes of cobalt violet, cerulean blue, and transparent oxide red. Next I paint the dark foreground areas with a mix of sap green, cobalt blue, and a bit of yellow ochre. Although I'm satisfied with the colors I've painted for the sky, I feel that the stronger values may compete with the painting's center of interest. To remedy this, I rework some of this area with plain water and a small flat brush to diffuse the edges and give it a more abstract feeling.

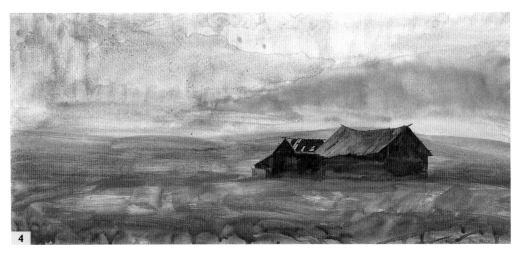

Step Four Using a medium flat brush, I block in the buildings with mixes of alizarin crimson, ultramarine blue, and transparent oxide red. Notice that the soft edges of the background element appear even softer now that there is a hard edge in the painting. At this point, nothing competes with the hard edge on the top of the barn for the center of interest. To maintain this focal point, I make sure that no other edges are as hard as those on the barn. I continue blocking in more of the foreground areas with a large filbert bristle brush and mixes of transparent oxide red, yellow ochre, and chromium oxide green.

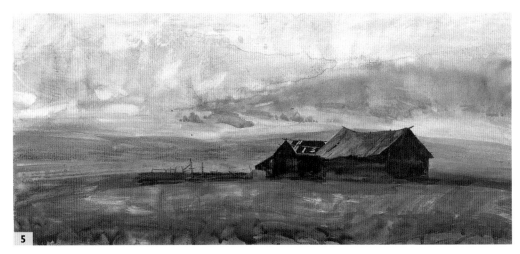

Step Five With a large flat bristle brush, I block in some of the foreground darks with a mixture of sap green and transparent oxide red. I make sure I keep the foreground values light enough so that they are not distracting and do not compete with the center of interest. Then I use cerulean blue and some white with a small flat brush to lay in a strip of blue directly behind the barn and across the width of the entire painting—this strip of blue establishes a base for the green I will apply over it in the next step.

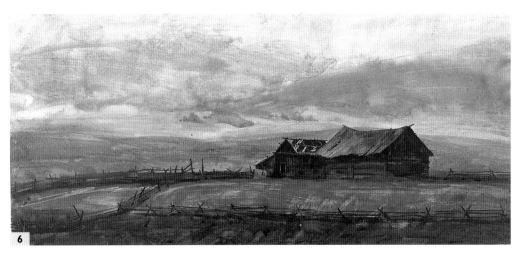

Step Six Using the drybrush technique, I drag a large filbert bristle brush with cerulean blue, cobalt blue, and cobalt violet across the background hills, letting little bits of the underlying paint show through as streaks. As I suggest the background forms, I make sure the edges are subdued and don't compete with the center of interest or appear unnaturally close. Then I use a small flat brush to apply a wash of chromium oxide green and yellow ochre over the blue undertone behind the barn. For the fence, I use transparent oxide red and ivory black on a small round sable brush with quick, loose strokes. I switch to the large filbert bristle and wash in the stronger mountain shapes with cerulean blue, cobalt blue, and cobalt violet.

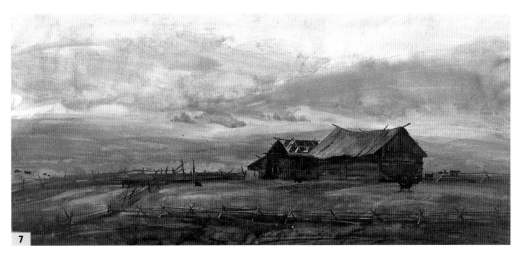

Step Seven Next I use a paper towel and water to rub out and soften a few foreground edges. Then I load a small flat brush with transparent oxide red and ivory black and dab in a few dots to suggest some cows in the foreground. Don't worry if some of the edges don't conform to every rule or aren't as precisely executed as they would be in a studio painting. Some of the charm of plein air painting comes from painting simply and directly. Although you want to paint accurately, there are times when the lack of perfect refinement can be a plus.

27

Studying Color "Temperature"

Light is a fascinating and elemental part of any plein air painting. Both light and shadow are full of numerous colors, both warm and cool. If you have a warm light source—such as the sun on a clear day—the areas in light will be warm and the shadows will be relatively cooler. If the light source is cool, as on an overcast day, the opposite is true (cool light areas and warmer shadows). I use the terms *warm* and *cool* relatively because the color of the light is only half of the equation; the color of the object itself (its *local color*) provides the other half. For example, if you paint green grass under warm sunlight as shown in this lesson, the local color of the grass mixes with the warm light temperature, producing a warm green in the lights and a cooler green in the shadows. Both are green and considered cool in the color spectrum, but relative to each other, one is warm and the other is cool. On the other hand, if you have white objects under warm sunlight, such as the girls' dresses in this painting, then the lights will be yellow-orange and the shadows will be cool. This is because the white object has no local color to mix with the color of the light. Applying these principles to your plein air paintings will add to their sense of accuracy and realism.

Step One For this scene, I hired a couple of models to pose for me. Once we started working, I was fascinated by the play of light on their dresses and the way it contrasts with the dark shadows. I decided this would make a unique and interesting painting. After lightly and carefully drawing the two girls on 300-lb watercolor paper, I begin with my center of interest—the girl in profile on the right side. Using a small flat watercolor brush, I wash in some yellow ochre and a touch of cobalt blue for the light of her forehead; cadmium red medium and yellow ochre for the lights along the rim of her face; and cadmium yellow light, cadmium orange, and cadmium red medium for the flowers in her hair. For her face, I lay in some sap green, cobalt blue, and permanent rose. Next I use a small flat brush to block in the shadowed area of her face with cobalt violet and touches of yellow ochre and cobalt blue. Because of the bright sunlight, the light areas are very warm and the shadows are relatively cool. Switching to a small flat brush and a small filbert bristle brush, I block in the girl's hair with transparent oxide red, cobalt violet, and ultramarine blue.

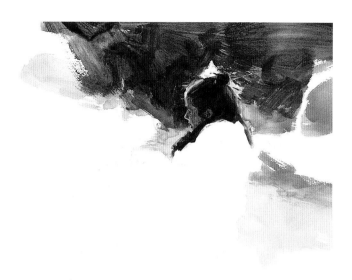

2

Step Two With a large flat bristle and a medium filbert bristle, I lay in a large section of the cool shadowed background with sap green, cobalt blue, viridian green, and a touch of permanent rose. Using a round detail brush, I darken the girl's nose with some pure cobalt violet. Next I apply a unifying wash of cobalt violet, transparent oxide red, and cobalt blue over the entire shadow side of the face. Just below the deep shadows in the background, I lay in a bit of the grass where it is struck by sunlight, using a large flat bristle and mixes of cadmium yellow light, emerald green, and a touch of cadmium orange.

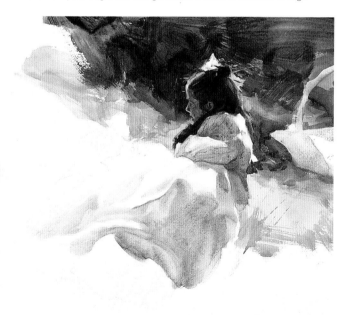

3

Step Three Now I paint the white dresses. You may not know that there is no such thing as pure white in nature; white objects actually reflect all the colors surrounding them. So first I use a large filbert bristle to thinly wash cadmium lemon and cobalt violet over all the sunlit areas of the dress. Then I block in the shadows with cerulean blue, cobalt blue, and cobalt violet. To suggest a few stripes on the sleeve, I use a small flat brush and cobalt blue.

29

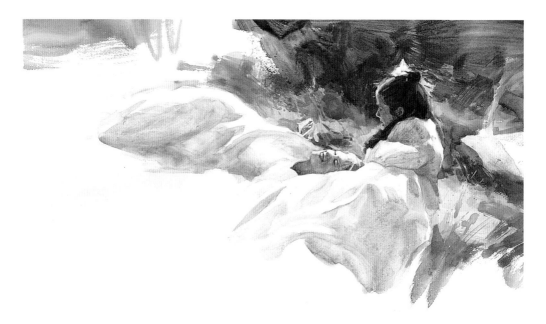

4

Step Four Next I use a small flat brush again and block in the shadow side of the other girl's face with mixes of cobalt violet, ultramarine blue, and transparent oxide red. Then I apply yellow ochre for the light side of her face. I paint the shadow of the dress with cobalt blue, cerulean blue, and cobalt violet. Then, using a large flat bristle brush, I begin painting the grass in the upper left corner with ivory black, cadmium yellow light, and emerald green.

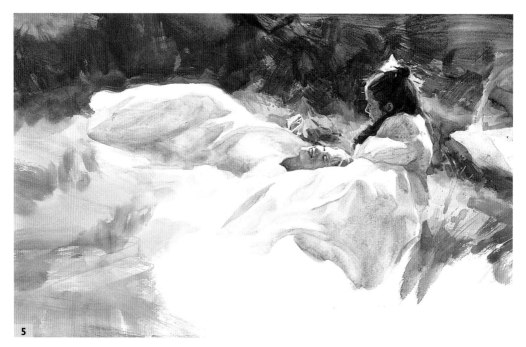

5

Step Five For the sunlit area of the grass, I use a large flat bristle and wash in cadmium yellow light, cadmium orange, and emerald green. Now you can really see the effect of the opposite color temperatures at work. Notice the relatively cool greens in the shadows as compared to the warm greens in the light. Also note the warm-cool relationship in the white dress and the face. The goal is to keep this same consistency throughout the entire painting.

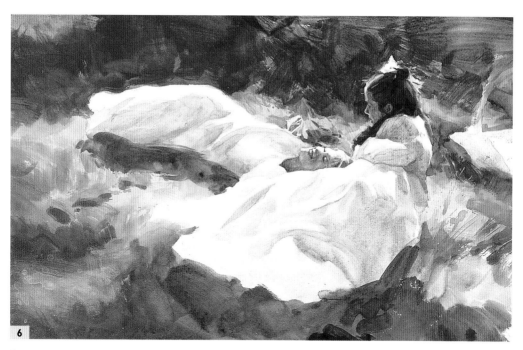

Step Six I continue developing the grass—both the shadows and the light values. Then I paint the flowers with a large flat brush, dabbing in a bit of cadmium orange for the flowers on the left. For the white flowers on the right, I lightly wash a mix of ivory black and cadmium red medium. For the deep red flowers below the white ones, I mix quinacridone rose, cadmium red medium, and yellow ochre. The complementary reds and oranges add interest without detracting from the focal point.

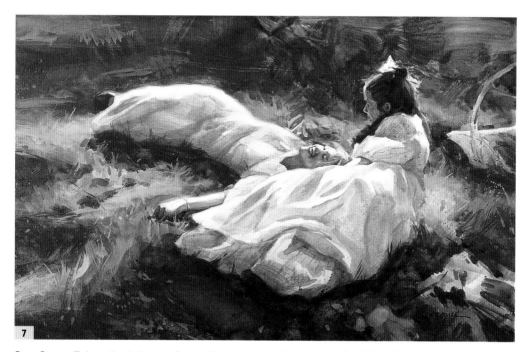

Step Seven To keep the dark greens from getting too dense, I dampen a large flat bristle with clean water, make a few light strokes, and then quickly rub off some paint with a paper towel. Then I add more detail to the dresses, the faces, and the grass. With a small flat brush, I add a warm glow to the top edge of the girl's dress on the left with cobalt violet, permanent rose, and cadmium yellow light. Then I scatter a few red and warm green accents in the grass to finish the painting.

Using Color Harmony

Color harmony is created by the unifying aspect of the dominant color, or combination of colors, in a painting. And color harmonies enhance your plein air paintings by creating visual interest and a sense of order and balance. The light source provides a natural color harmony by unifying the lights and shadows with a particular color cast. For example, an overcast day will have a cool, silvery color harmony with warm shadows; a clear day at dusk will have a warmer golden orange color with deep purple shadows; and a sunny day at noon will have very yellow lights and very blue shadows. This painting of a sunlit glacier peak has an overall warm color harmony provided by the warm light of the sun. But just because the sun is yellow, it doesn't mean I will use pure yellow for sunlit areas and pure blue for shadows. (The only pure yellow would be used on a yellow object, such as a daffodil.) As you can see in this painting, the yellow cast creates harmony, but there isn't a single use of pure yellow.

Step One When painting in the snow, I bring a small rubber mat or thick piece of cardboard to stand on. This keeps my shoes from touching the frozen ground and makes a world of difference! I begin by sketching the underlying drawing of the mountains with pencil on cold-press watercolor board. The actual scene is quite a bit wider, but I compress some of the mountains to make a more pleasing composition. Then, using a large flat bristle brush, I apply a wash of Payne's gray and raw sienna to the lightest lights of the snow patterns. I make the distant glaciers a little darker by adding a touch of alizarin crimson. I will eventually go even darker and warmer for the majority of these snow areas, but for now I am just toning down the white of the board and painting the lightest values in the painting.

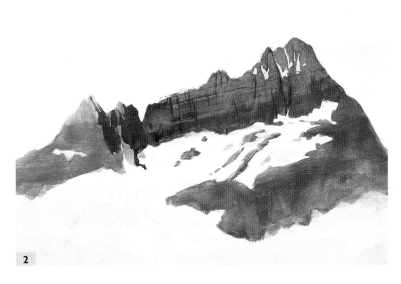

Step Two Now I block in the foreground mountain, using medium and large filbert bristle brushes for the large shapes and a small flat brush for the details. All three bands of rock color—orange, blue, and red—have a distinct yellow, sunlit tint. To create this natural, yellowish color harmony, I mix a bit of yellow ochre into the burnt sienna top layer; the ultramarine blue and cerulean blue middle layer; and the alizarin crimson bottom layer. Without the unifying yellow ochre, the colors would look garish and unnatural. For the deep shadows, I use ultramarine blue and alizarin crimson.

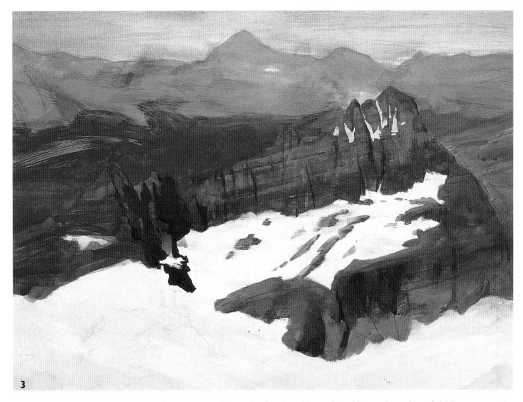

Step Three Next I use a medium flat bristle brush to paint the sky with cerulean blue and touches of viridian green and yellow ochre—even the sky's colors are influenced by the color of the light. With the same brush, I move on to the distant mountains, using increasingly cooler colors as each set of mountains recedes. (See the detail on page 34.) For the farthest peaks, I mix ultramarine blue, alizarin crimson, and a touch of yellow ochre. For the middle set of mountains, I add a little white to the same colors to make them a bit opaque and a little warmer. Then I add the striking blues of the shadowed valley with ultramarine blue and alizarin crimson, with just a bit of cerulean blue. Because these areas are in shadow, their temperature is predominantly cool, so this is the one time where I come close to using a pure primary color.

33

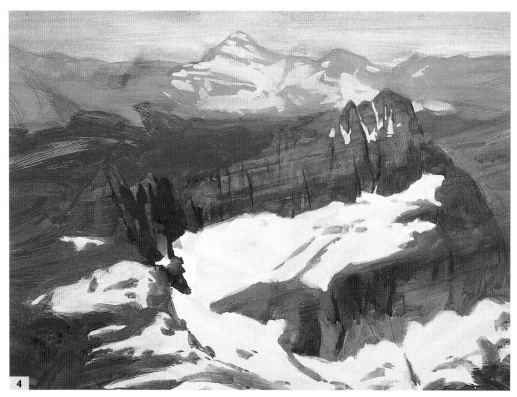

Step Four Using opaque white, yellow ochre, and cerulean blue on a small flat brush, I paint the glacier shapes on the distant mountains. I also darken and warm up the foreground glaciers with a large flat bristle brush. I continue adding the shapes of the lower half of the mountain with the same mixtures I used in step three, but this time I add a few touches of viridian green, cadmium yellow light, and cadmium red medium. Green can be the trickiest color to paint in the sunlight— the tendency is to go too cool, so make sure you add enough yellow and red to maintain the overall warm harmony.

Distant Mountain Detail For the receding mountains, I apply the principle of *atmospheric perspective*: Because there are dust particles and moisture in the air that block some of the light rays, objects in the distance appear cooler, paler, and less detailed than those that are closer. I blur the mountain details and use increasingly cooler values of blue as they fade into the distance. (For more on atmospheric perspective, see also "Creating Depth with Atmosphere" on page 46.)

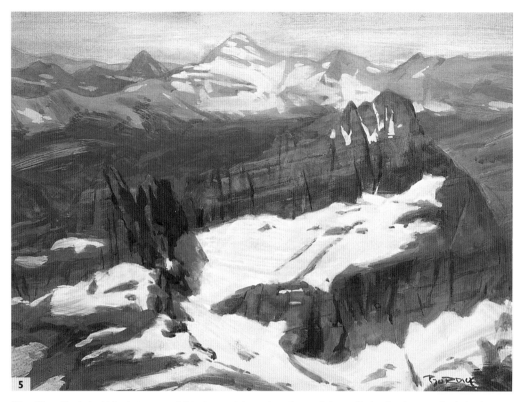

Step Five Finally I add the last group of distant mountains and continue refining and balancing the overall painting. Just to the left of center is one of the few shadows that fall on the icy glacier itself. Here I use a mixture of cerulean blue and ultramarine blue, with just a hint of alizarin crimson. (Compare this cool shadow to the warm yellowish cast of the sunlit white next to it.) To intensify the warm-cool effect between shadow and light, I use a small flat brush to add a touch of cobalt turquoise above the left foreground peaks and a few glazes of cadmium orange on the right foreground peaks.

Rock Detail I use a mix of ultramarine blue and alizarin crimson to create the deep shadows in the rocks, adding traces of yellow ochre to maintain the color harmony. To enhance the sense of depth, I use more detail and more intense colors in the areas that are closer to the viewer.

Applying Impressionistic Color

The Impressionists are credited with taking a color, breaking it down into its primary components, and letting the eye (instead of the brush) mix them. When you use *impressionistic color* in your plein air paintings, you choose how to represent the colors you see in nature. There are many ways to create the impression of a particular color. You can place one color next to another and let your eye visually mix the two, as I did with the yellows and blues in this stand of trees—they all "read" as greens. Or you can pull yellow into blue wet-into-wet, drybrush one color over the other, or even use crosshatched yellow and blue lines. When using impressionistic color, be sure to have a clear idea about how colorful you want your final piece to be before you begin to paint. The purity of the first color you place on your canvas often determines the outcome of the painting, forcing you to balance it with either very pure or more subtle colors. I wanted this painting to resonate with natural, earthy colors, so I began with muted greens and browns in the foliage, and then balanced those colors with bright reds and oranges in the foreground.

I

Step One With a medium flat brush, I begin blocking in the mass of leaves with viridian green, cadmium yellow light, and transparent oxide red; then I paint the tree shadows with ultramarine blue and cobalt violet. The impressionistic color principle is evident even at this early stage; instead of completely mixing my colors on the palette, I apply multiple strokes of different colors to the same area (wet-into-wet) and let them flow together. I leave some areas more yellow, some more blue, and some more red, and I let the viewer's eye interpret it as green. Next I paint the sky with a large flat brush. I use the same wet-into-wet technique, but this time I use cobalt blue, viridian green, and cobalt violet.

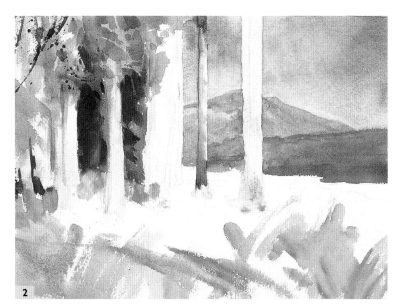

Step Two Next I paint the distant mountains using a small flat brush with a mix of cobalt blue and cobalt violet, adding olive green for the closer hills. Then, for the foreground, I use a large filbert bristle brush and add some strokes of a warm mixture of cadmium red medium, cadmium yellow light, and transparent oxide red. This establishes a warm base for the cooler colors that I'll apply later.

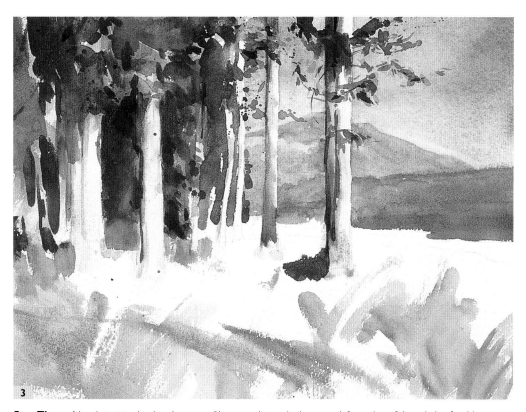

Step Three Now I start to develop the mass of leaves and trees in the upper left portion of the painting; for this step, I use both small and medium flat brushes. For the deep darks between the trees, I use mostly mixes of ultramarine blue and transparent oxide red. I apply many strokes of viridian green, sap green, ultramarine blue, yellow ochre, cadmium yellow light, and cadmium red medium to represent all the foliage. This may seem like a lot of colors to simply paint green, but notice that even though you can identify the small, individual spots of all these colors, the overall mass of color still "reads" as green to the viewer's eye.

37

Step Four Next I work some greens into the foreground to balance out the warm undertones. For this step, I use a large filbert bristle brush with mixes of olive green, transparent oxide red, and permanent rose. When I'm done with my painting, I want just a bit of this warmth to show through as an undertone, with maybe two or three highlights of pure color. Many landscape painters (in both watercolor and oil) use a red or orange undertone for their greens to keep them from becoming too stark and overpowering.

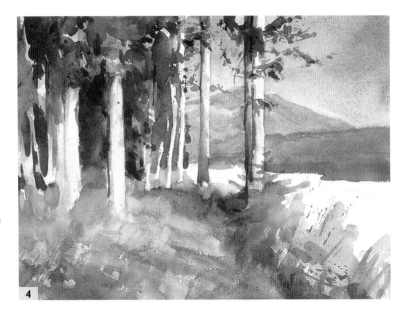

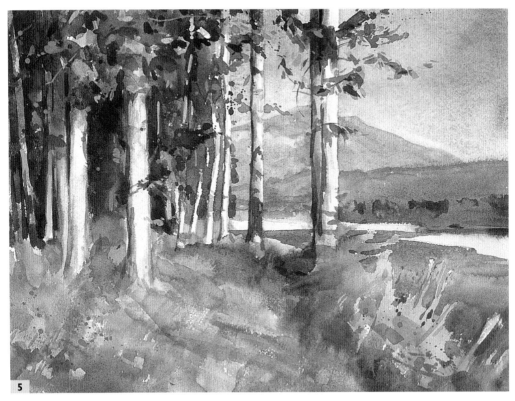

Step Five My next step is to paint in the river. I use a small flat brush and cobalt blue, cobalt violet, and a touch of viridian green. Then, with the same brush and the colors from step four, I continue refining the trees and the foliage as well.

38

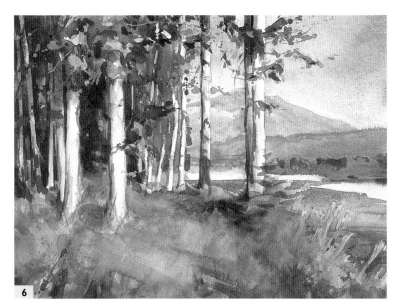

Step Six To finish the foreground, I use a large filbert bristle brush and scrub in a mixture of emerald green and cadmium yellow light to most of the area. This softens the colors, as the underlying warm colors mix with the green. The result is that the foreground has the soft edges that such grassy areas should, but it also has a wide range of subtle color changes. Notice that even though there are very few spots of pure green, you can still clearly identify the foreground as a grassy green slope.

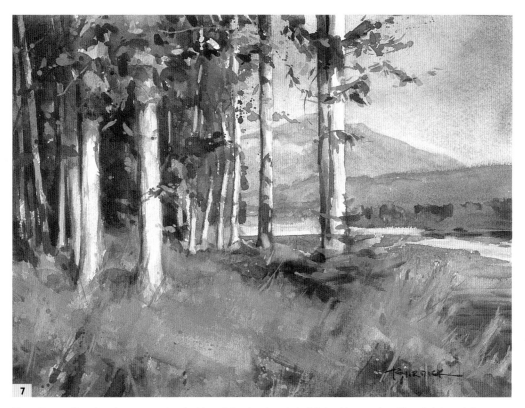

Step Seven To soften the grass against the blue of the river, I scrub it slightly with a medium filbert bristle and clean water. Then I add a few spots of pure cobalt violet, cadmium orange, and cadmium yellow to the foreground to finish my painting.

Integrating the Elements

When painting *en plein air,* sometimes you may need to take artistic license and alter the scene to improve the overall design or *composition* (the arrangement of elements). Creating a good composition relies on two elements: placing lights and darks into simple patterns, and balancing those patterns in a pleasing manner. Look at your subject in terms of shapes of lights and darks, and try to determine the patterns they create, such as the interlocking L-shaped light and dark masses in this painting. Then place your light and dark patterns so that they "feel" right to create *balance*—but that doesn't mean they have to be completely symmetrical! An unequal division of light and dark patterns will be more pleasing to the eye. And place your focal point slightly off center—such as the archway in this painting—for more visual interest. As you paint outdoors more frequently, you will start to recognize the general types of compositions, and you'll begin to constantly survey your surroundings for designs that catch your attention.

1

2

Step One Even at the sketching stage, I think about the distribution of light and dark patterns. For example, at this actual location, there were balconies on the left foreground windows with plants and other objects casting shadows; these shadows broke up the clean, simple light mass that is essential to the composition of this painting. I also made sure to sketch a few people as they walked just to the left of the archway, to help accentuate and connect the dark pattern of the arch down to the pavement. To keep the light shape framed by the arch simple and unified, I chose not to include any people in the distance.

Step Two With a large flat bristle brush, I apply a warm wash of yellow ochre, cadmium yellow light, cadmium lemon, and cadmium orange over the light patterns of all the buildings bathed in sunlight. Then, with a medium flat brush, I block in the sky using soft washes of cobalt blue and cobalt violet. I'm careful not to go too dark with this color but stay close in value to the sunlit buildings; this is because it's important that the sky still "reads" as part of the light pattern. Remind yourself to think first of the value and the pattern you're working on; then concentrate on the color afterward.

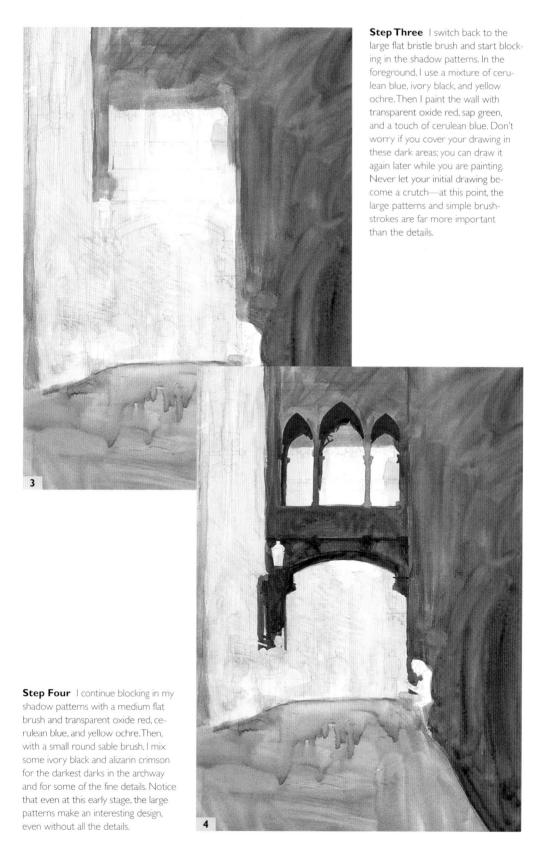

Step Three I switch back to the large flat bristle brush and start blocking in the shadow patterns. In the foreground, I use a mixture of cerulean blue, ivory black, and yellow ochre. Then I paint the wall with transparent oxide red, sap green, and a touch of cerulean blue. Don't worry if you cover your drawing in these dark areas; you can draw it again later while you are painting. Never let your initial drawing become a crutch—at this point, the large patterns and simple brushstrokes are far more important than the details.

3

Step Four I continue blocking in my shadow patterns with a medium flat brush and transparent oxide red, cerulean blue, and yellow ochre. Then, with a small round sable brush, I mix some ivory black and alizarin crimson for the darkest darks in the archway and for some of the fine details. Notice that even at this early stage, the large patterns make an interesting design, even without all the details.

4

41

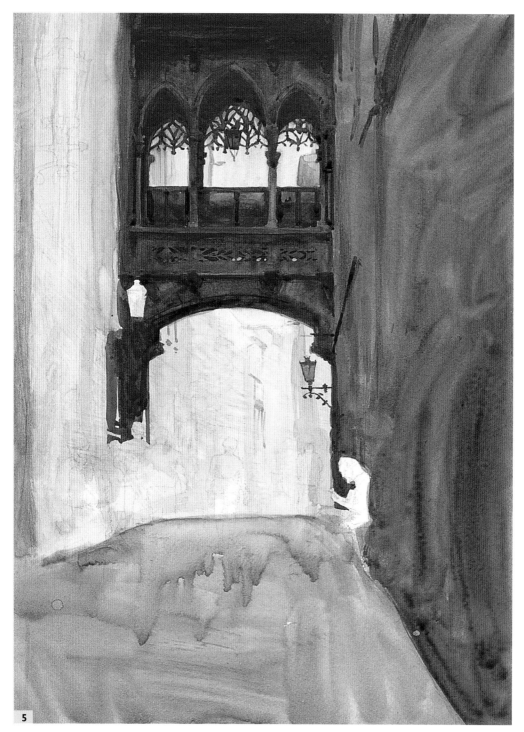

Step Five Next I use a large flat brush to slightly strengthen the values of the sky with mixes of cobalt blue, cobalt violet, and a touch of transparent oxide red. On the left wall, I add a light wash of cadmium red medium, cadmium orange, and white with a large flat brush. Then I switch to a small round sable brush to paint some of the details of the archway with transparent oxide red and ivory black. Now that some of the large patterns are present, I can begin to add some details.

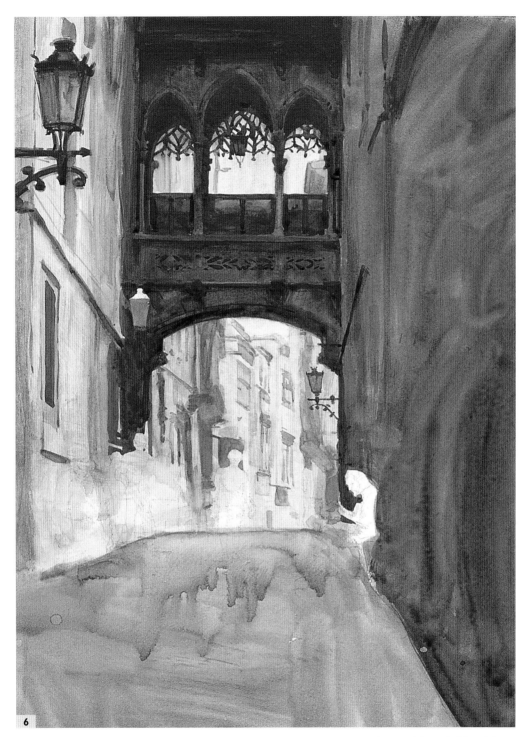

6

Step Six I use a small sable brush to paint the shadows, the windows, and the other details beyond the arch. Although I use a multitude of colors here, they are all mixed with a bit of cadmium yellow and cadmium orange for a sense of color harmony. (See page 32.) I paint the light in the upper left corner with a small flat brush and chromium oxide green, transparent oxide red, and ivory black. Then I add the silhouette of a pedestrian under the archway to accentuate the surrounding light.

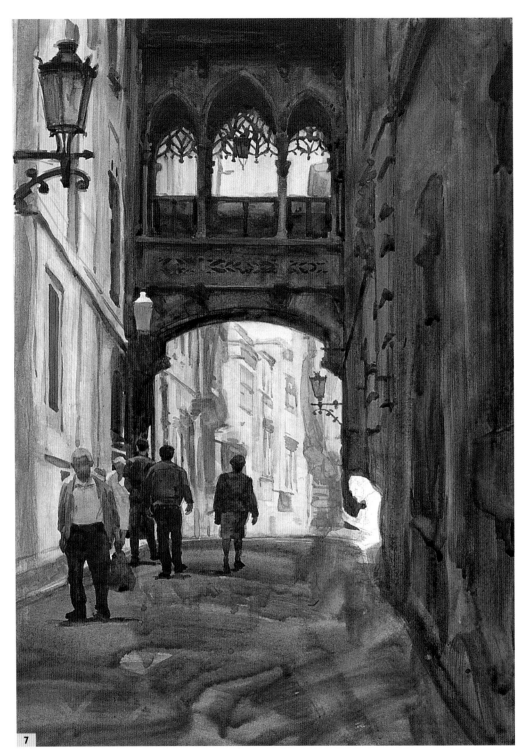

Step Seven For the dark crevices of the stones on the right wall, I use a small flat brush with transparent oxide red, ivory black, and a touch of chromium oxide green. Next I add a slightly darker wash over the foreground with the large filbert bristle and alizarin crimson, cerulean blue, and a touch of yellow ochre. Then I lay in the figures using a small flat brush with ultramarine blue, alizarin crimson, and transparent oxide red. Notice that the figures complete the circular dark pattern of the archway. (For more on painting figures, see page 11.)

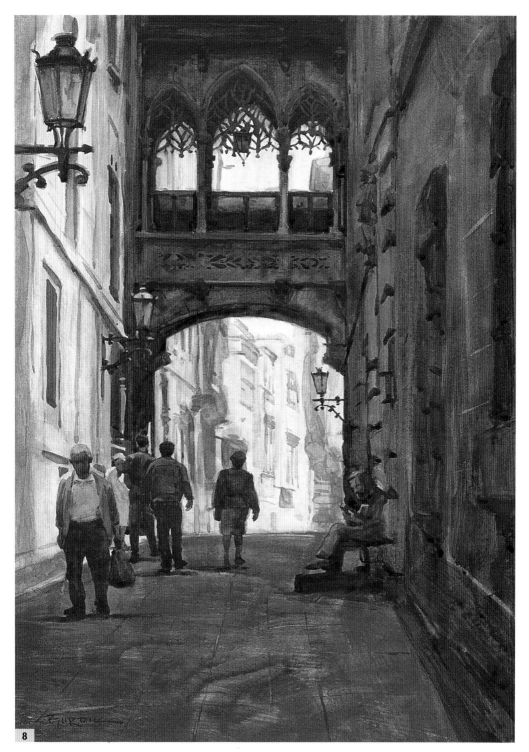

Step Eight Now I use a small sable for the guitar player with alizarin crimson, ultramarine blue, and transparent oxide red. With a small flat brush, I finish the dark accents on the right wall with ivory black, alizarin crimson, and transparent oxide red, using only enough detail to suggest the form—too much detail will take away from the larger patterns. To keep the foreground in color harmony, I use a large flat bristle to drag across a few strokes of chromium oxide green, yellow ochre, and transparent oxide red. Finally I add a light wash of cerulean blue and white over the lights of the distant buildings to ease their transition into the sky.

Creating Depth with Atmosphere

Nature provides help in creating the illusion of depth in a landscape painting because particles in the atmosphere cool the colors and blur the details of objects in the distance. So incorporating this phenomenon in your artwork by making elements in the background grayer and less detailed than objects in the foreground (referred to as using *atmospheric* or *aerial perspective*) will instantly create a sense of depth. In this scene, for example, the moisture in the air blocks out some of the color and details on the distant mountain peak—making the mountain appear cooler in color and compressing its values into the middle range. You can also adjust your viewpoint so the elements of your scene accentuate the feeling of depth. For instance, when deciding where to set up for this lesson, I chose a spot where the dark foreground trees overlapped the form of the mountain. Notice how the dark values of the trees set against the subtle blue-gray of the mountain makes the mountain appear to be set back quite far in the distance. When you see an outdoor subject that interests you, walk around and look at it from different angles; this way you can observe how other elements visually enhance or detract from the subject.

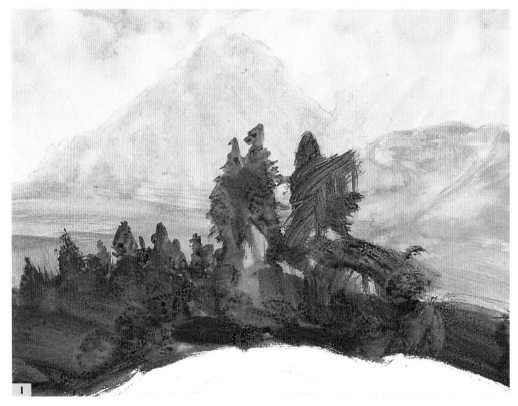

Step One After sketching the scene on a cold-press watercolor board, I apply an initial wash over the sky and mountain with a large filbert bristle and a mix of cobalt blue, quinacridone rose, cadmium orange, and a little Chinese white. I block in the mountains on the right with quinacridone rose, cobalt blue, yellow ochre, and a bit of white for the upper area; I use the same colors plus some emerald green for the lower areas. For the trees, I use sap green, transparent oxide red, and yellow ochre.

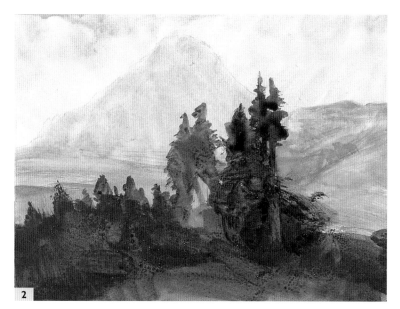

Step Two Still using the large filbert bristle brush, I block in the valley on the left with washes of cobalt blue, cerulean blue, and emerald green. I continue to develop the forms of the trees and the foliage in the foreground. Notice how much the addition of these dark shapes sets off the faded values of the distant mountain.

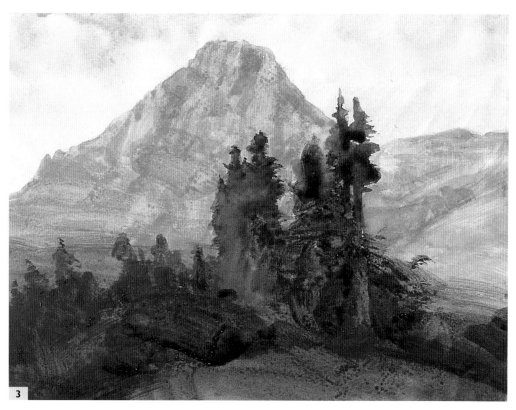

Step Three Using a small round brush, I add some dark details to the foreground trees with mixes of sap green, ultramarine blue, and some cobalt violet. Notice that I keep the most vibrant colors in the foreground of my painting so that they "pop" forward in the composition. The cooler colors used in the distant mountain make it appear to recede in the distance. At this point I just paint the large shapes and colors of the mountain before I move on to the details.

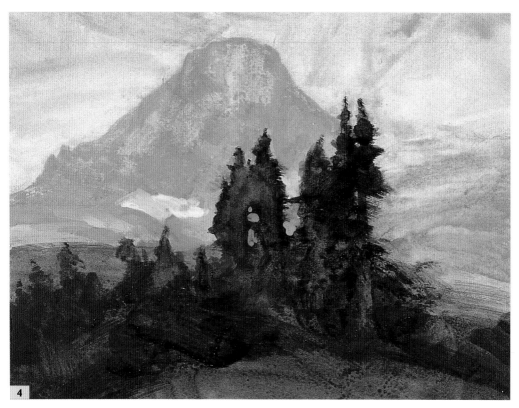

Step Four Now I define the forms of the distant mountain further with a medium flat bristle brush and mixes of cobalt blue, viridian green, and cobalt violet. I make sure to use cool tones, which are not as vibrant as those in the foreground. Then I add the suggestion of formations in the water. I want to keep this detail to a minimum so I don't detract from the center of interest and the other objects in the foreground.

Step Five To create a sense of unity, I wet a medium filbert bristle with clean water and blend the forms. Then, with a medium flat bristle, I rework the mountains with cobalt blue, viridian green, and cobalt violet. Next I add yellow ochre and cadmium orange over the lower right hill. With a medium flat brush and ultramarine blue, transparent oxide red, and yellow ochre, I add shadows on the upper ridge. Then I use a small flat brush for the tree trunks, painting the shadowed trunks with cerulean blue and white, adding cadmium orange and cadmium yellow light for sunlit spots.

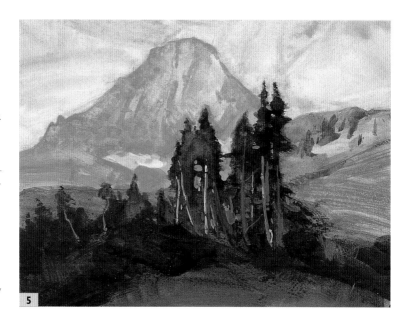

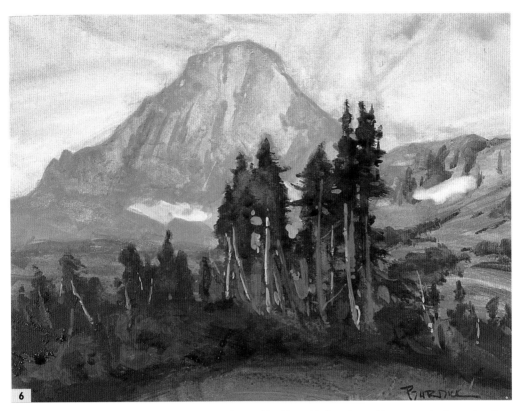

Step Six Finally I add the distant tree shapes on the lower right ridge with chromium oxide green and yellow ochre. For the few warm spots of color in the foreground, I use a small flat brush with cadmium red medium, a touch of viridian green, and some white. I step back to assess my painting and decide I've achieved the sense of depth and dimension I wanted.

Positioning the Horizon Line for Good Composition

Good Format: High Horizon

Think of this composition as divided horizontally into thirds. The horizon line is set on the upper third of the composition, which means that the foreground and middle ground are emphasized.

Good Format: Low Horizon

When the horizon line is low, the sky or a large subject in the background stand out. In this scene, the sky is dominant and the diagonal path in the foreground leads to the row of houses on the horizon line.

Bad Format: Centered Horizon

This is a stagnant composition because the center of interest is right in the center of the picture field. The scene looks flat and one-dimensional, and there are no devices to lead your eye through and around it.

Understanding Abstract

Paintings done on location are rarely photorealistic. The time constraints require that you work quickly and somewhat loosely. You must determine how much of your painting to leave abstract, how much to leave vague or blank, and how much to tightly render. There's no formula for how much should be left to the viewer's imagination and what should be spelled out in detail, but my favorite paintings usually contain some of both, as in this painting of a café scene—the doorway and façade are highly detailed, while the figures on the left are merely suggested. First decide what about the subject interests you most—what adds to the center of interest—and then give that element the most detail. Remember that everything in a painting is relative; a tightly rendered area will look even more realistic against a loose, abstract background.

Step One After sketching my drawing on 300-lb watercolor paper, I use large flat and filbert bristle brushes to wash over the wall with transparent oxide red, permanent rose, and cadmium yellow. While it's still wet, I add vertical slashes of cobalt blue and cobalt violet to the wall. Next I wash in some of the doorway using a large flat brush with ultramarine blue, yellow ochre, cadmium lemon, and a bit of cobalt violet. Still using the large flat brush, I wash in some cadmium lemon, yellow ochre, and ultramarine blue for the light areas of the figures, adding ultramarine blue and cobalt violet for the foreground. I try to make loose strokes and "drippy" patterns throughout that have character and interest.

Step Two I paint the slightly off-center doorway with medium and large flat brushes and mixes of ultramarine blue, alizarin crimson, and transparent oxide red. The doorway and the waiter will be my center of interest, so I put the most careful detail in this area.

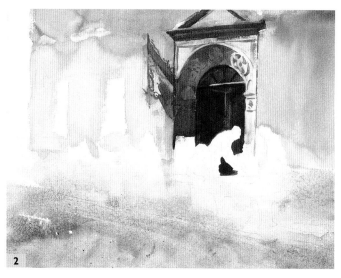

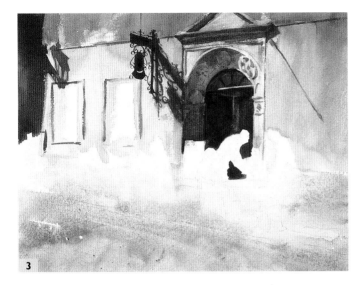

Step Three With a large filbert bristle brush and a small flat brush, I paint the shadows on the wall with a mix of alizarin crimson and cobalt blue. Notice the interesting variety in the large shadow on the extreme left and how this gives even such a flat pattern more depth. For the sign, I apply ultramarine blue and alizarin crimson with a small flat brush. Next I use a large filbert bristle to strengthen the upper part of the wall with permanent rose, cadmium red medium, and a little sap green.

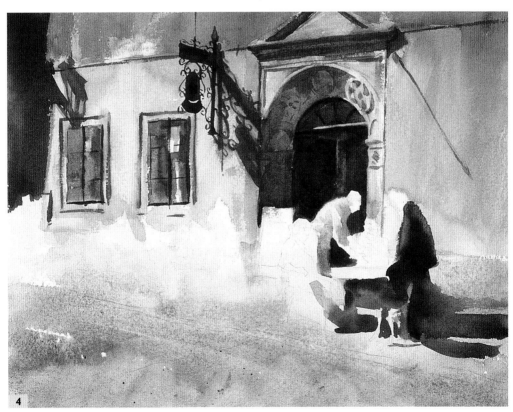

Step Four Now I block in the large shapes of the windows with a medium flat brush and a mix of sap green, cobalt blue, and alizarin crimson. For the delicate lines of the window panes, I use ultramarine blue and alizarin crimson on a round detail brush. For the shadow on the waiter's clothes, I switch back to the medium flat brush and use cobalt blue and permanent rose. With ultramarine blue and alizarin crimson, I start blocking in a few of the dark shapes of the patrons on the right.

Step Five For the people, I use small, medium, and large flat brushes and a full variety of colors. (See also page 11.) Notice that I paint the shapes and colors in a general way, without actually painting all the objects or details; this would distract from the focus of the painting. These simple, abstract patterns and shapes, which might seem like random blobs of paint by themselves, become recognizable objects in the context of the whole painting when viewed from some distance. I also add the lamp in the upper left corner with a mix of ultramarine blue and alizarin crimson for the darks and a mix of cerulean blue, permanent rose, and a touch of white for the lights.

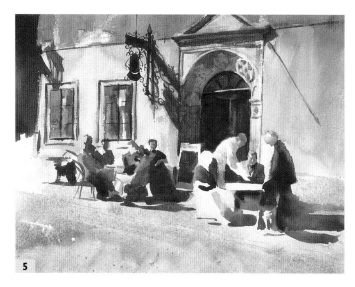

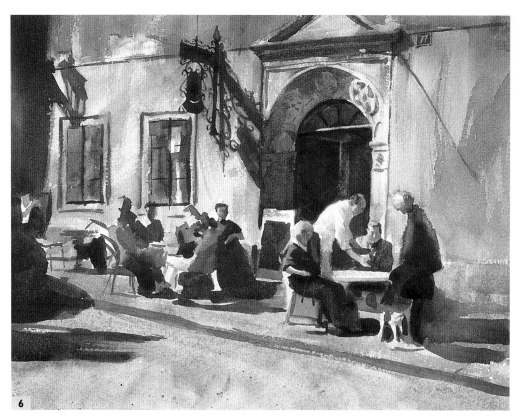

Step Six I continue working the figures at the tables; then I use transparent oxide red, cobalt blue, and cobalt violet on a large filbert bristle to dash a few more strokes over the background wall. Using the same brush, and mixes of ultramarine blue, alizarin crimson, and transparent oxide red, I block in some of the dark, shadowy shapes on the left side of the foreground.

Using a Viewfinder

When you're painting on location, a viewfinder can be a time-saving tool. A viewfinder helps you zero in on one section of a scene and block out any unnecessary elements. It also helps establish which format will make the most effective composition. A viewfinder consists of two simple L-shaped frames, and they can be attached with paper or binder clips to make them easily adjustable. You can buy a viewfinder at an art supply store, make your own out of cardboard, or even use your own thumbs and forefingers. Hold the viewfinder up and look through the opening at the scene in front of you. Bring it closer to you or hold it farther away; turn it sideways and move it around. Then choose the view you like best.

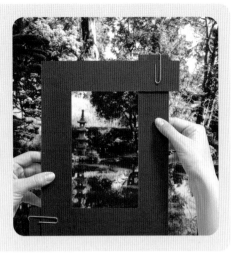

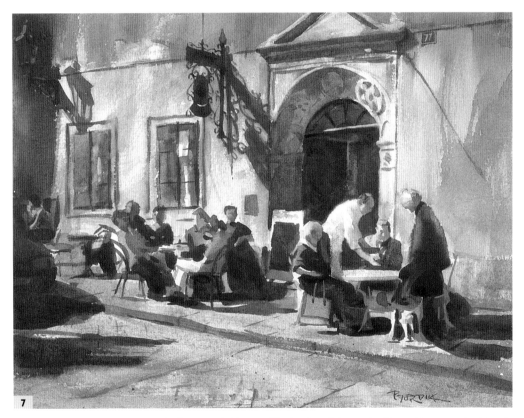

Step Seven | I add some details to the foreground with a small flat brush and ultramarine blue and transparent oxide red. Then I look to see whether I've achieved the proper balance between abstract and detail. Certainly this painting could be done far more loosely (abstract), or tightly (detailed), but I am pleased with it as it is. Practice painting both extremes, so that you can decide where to set the balance for any particular subject.

Working with Variety and Opposites

For nearly every component of a painting, you can create its opposite (its *counterpoint*)—for example, dark versus light, bright versus gray, soft versus hard, loose versus tight, and simple versus busy. In other words, if you want a certain edge to look especially sharp, then you must soften everything else in the painting to accentuate the sense of hardness. Or if you want a color to look especially brilliant, then you must gray down everything around it (or use the color's opposite temperature). Variety is the key; if you use pure colors on everything in an attempt to make a painting look colorful, you will see that the power of each individual color is lost. Whenever you see a color, an edge, or a value that jumps out at you in a painting, look at the areas surrounding it to see how the effect was achieved. In this painting, the pure warm colors on the boat are the opposite of the cool colors in the water and background.

Step One First I sketch the basic structure of the boat on 300-lb watercolor paper with a #2 pencil—this stage is important when painting outdoor subjects that may move. Using a large flat bristle brush, I tone the entire surface of the image with a wash of cerulean blue, cobalt violet, and a bit of emerald green. Before this initial wash is dry, I wash in the tree shapes with a slightly darker version of the same colors, with a bit of yellow ochre and transparent oxide red added for the rocks. Using a small flat brush and clean water, I rub out some light areas on the boats and in the buildings. Then, with the same brush, I begin painting the shadows within the cabin of the boat using transparent oxide red and ivory black. I use cadmium orange, cadmium red medium, and permanent rose mixed with some cerulean blue for the color accents.

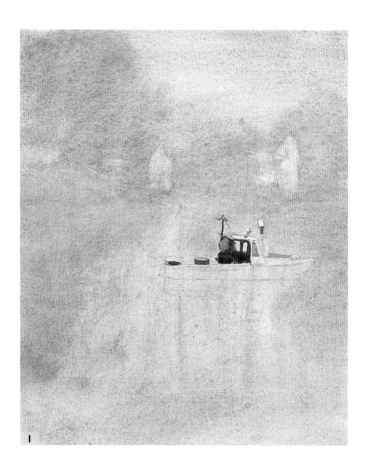

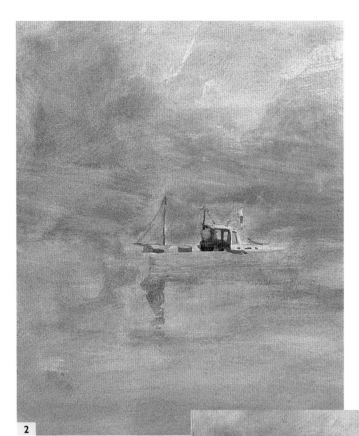

Step Two With a medium flat brush, I mix some yellow ochre into the previous gray-blue on my palette and wash in the underside of the boat. Then, with a small flat brush, I block in the sail and its reflection with emerald green, viri-dian green, and cobalt blue. Feeling that the background and water colors are just a little weak for the final light effect I have in mind, I wash more cerulean blue, cobalt violet, olive green, and Chinese white over most of the painting with a large filbert bristle brush. Even though the light from the lantern will be among the last things I paint, it will be my lightest value, my brightest color, and the center of interest, so I need to keep it in mind when painting everything else.

Step Three Using a small flat brush and a small round sable, I concentrate on all the details of the boat. Although I apply a range of colors here, I'm always conscious of keeping them from getting as light or as warm as the boat's lantern will eventually be. At this point, I also use a small flat brush and a mix of transparent oxide red and cerulean blue to indicate a few waves in the foreground.

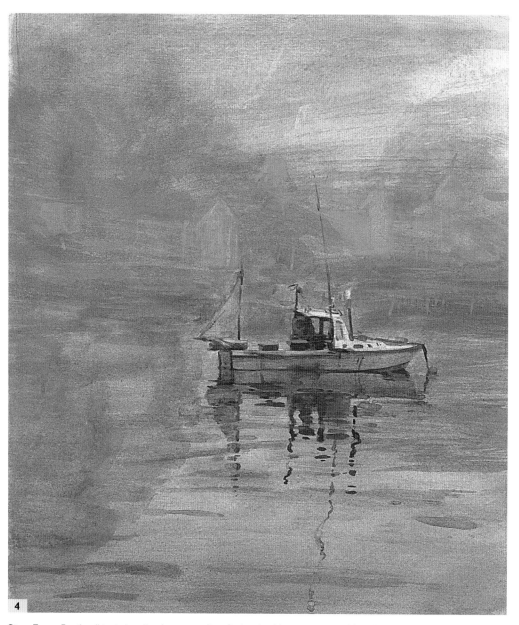

4

Step Four For the distant shoreline, I use a medium flat brush with transparent oxide red, cerulean blue, and white. To unify and soften some of the edges, I mix cerulean blue, cobalt violet, and yellow ochre and drag some large streaks across the boat and background with a large filbert bristle brush. Then I go back to the medium flat brush and use cobalt blue, white, and transparent oxide red to suggest some of the lighter portions of the houses.

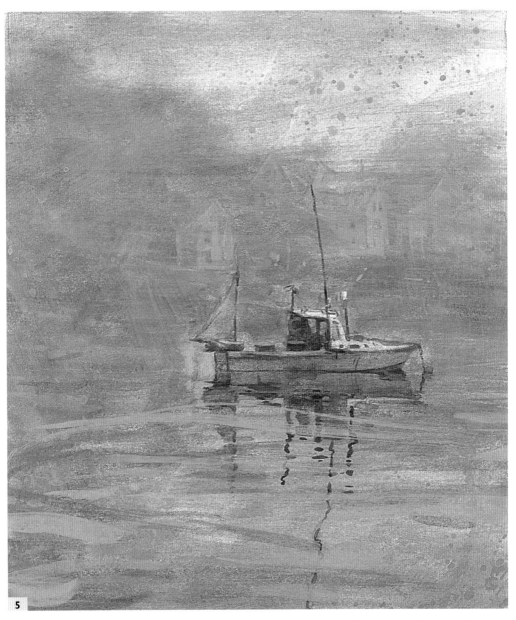

5

Step Five Next I use medium and small flat brushes to place some of the darks in the windows of the houses. These dark values are light and faint at this point, but the addition of bright highlights later will make these darks stand out more. Just for fun and variety, I splatter a bit of cobalt blue and white here and there; then I use the small flat brush with cobalt blue, cobalt violet, emerald green, and white to splash in some more light wave patterns in the foreground.

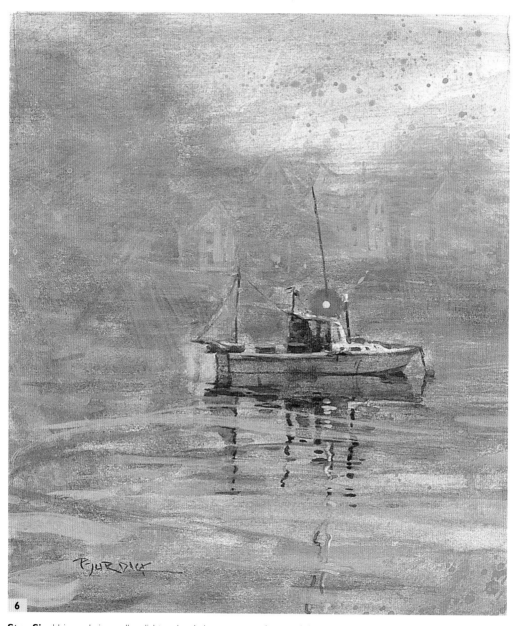

6

Step Six Using cadmium yellow light and cadmium orange and a round detail brush, I paint the lantern of the boat and then the reflection of the lantern's light in the water. Next I add some cadmium red medium to this mixture to portray the glow of the lights. Surrounded by all the soft blues, the boat's pure, warm colors and hard edges make a dramatic impact.

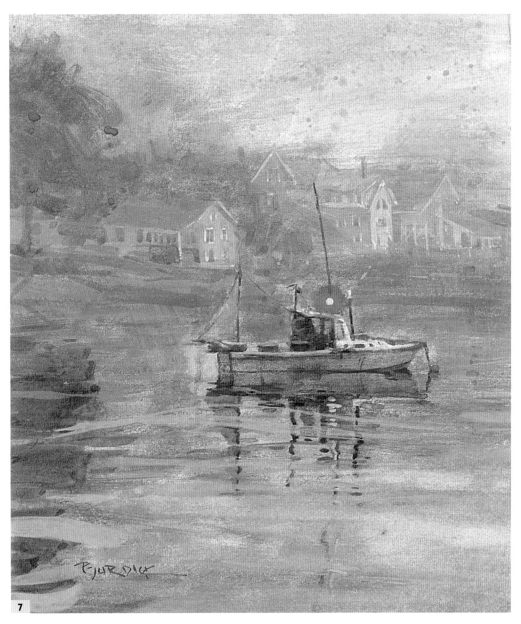

Step Seven With a small flat brush, I add more details to the houses; then I use a damp paper towel to soften some of the strokes in the sky and the lower right area of the water. Finally I paint some dark values on the left tree and its reflection in the water with a small flat bristle and ivory black, cobalt blue, emerald green, and cobalt violet.

Narrowing Your Selection

Many times what you choose to leave out of a painting has as much to do with its success as what you actually paint. You want the viewer to be able to focus on your center of interest without a lot of distracting details. And painting outdoors forces you to focus on what's essential, since you have limited time and light in which to complete a painting. Once you've decided on a subject and a composition, take a moment before starting to paint and choose what your center of interest will be—it should be the element that most interests you and what you want the viewer to see first and foremost. Here I narrowed the focus to a closeup of a few flowers in a simple composition. I left out not only the background and other landscape elements but also even the rest of the field of flowers—this places the focus solely on the forms and the angles of light and shadow in this scene.

Simplifying for Contrast This photo captures the scene as I found it; you can see how much I simplified the foliage in the foreground to emphasize the flowers, my center of interest. Instead of rendering each individual leaf and stem, I used broad, loose strokes that contrast with the more tightly rendered brushstrokes I used for the daisies.

Step One Skipping the drawing stage, I use a large flat bristle brush and cover the entire paper with a wash of permanent rose, cobalt violet, and just a touch of emerald green. My plan is to start with my center of interest and move from flower to flower, including only those blossoms that add to the design. I want to make sure the final painting isn't too busy or disjointed.

Step Two I paint the dark shapes around the main daisy's petals with a small flat brush and a mix of cobalt blue, alizarin crimson, and sap green. I use the same brush to block in the daisy's center with transparent oxide red, cadmium red medium, and sap green; then I add some cobalt violet for the darker petals. With a large filbert bristle, I block in some of the dark areas below the daisy with the same background colors. I don't need to render a perfect likeness of every flower—this subject lets me be very free about adjusting the shape, placement, and number of petals.

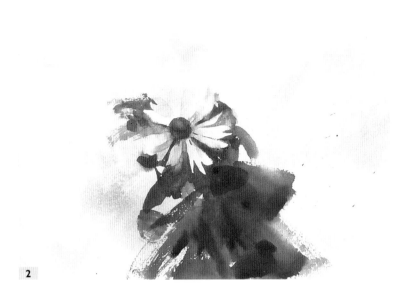

2

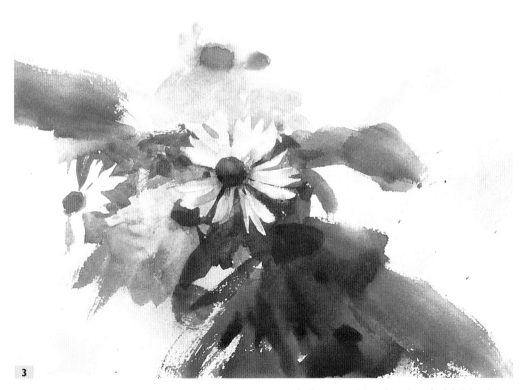

3

Step Three I place strokes of cobalt blue and cobalt violet to the left of the large daisy using a large flat bristle brush; then I add some permanent rose and cobalt violet. This serves as a base for some of the darker flowers that surround the main bloom. With a small flat brush, I continue working the negative shapes around the adjacent flowers' petals with some sap green and cobalt violet.

Step Four I continue to use various mixes of cobalt blue, alizarin crimson, cobalt violet, permanent rose, and sap green to develop the shapes around the daisies. Since all the flowers and background elements are so similar, my challenge is to work them all into a coherent design. I must also select which petals and flowers to paint in detail and which to suggest. If I paint all of the flowers with the same degree of detail, none of them will stand out from the others.

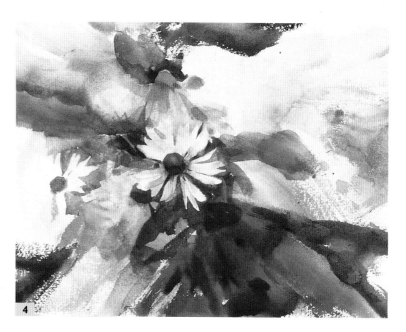

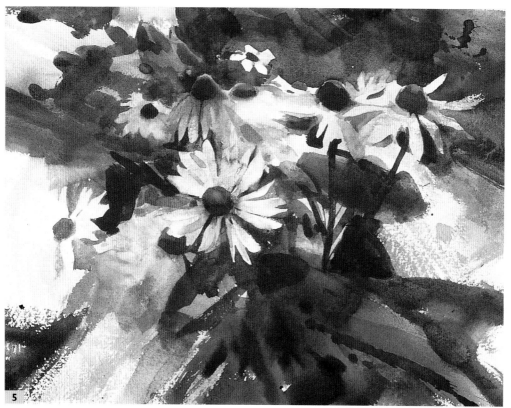

Step Five As I add more flowers to my painting, I group them together a bit more closely than they actually are in the outdoor scene. I also leave out some of the central flowers that overlap. The overlapping flowers made the composition too busy and detracted from the simplicity of the design I want to achieve. Notice that I start with the simple shape of the flower and its petals and then work the edges later. This allows me to evaluate their placement before I add the details.

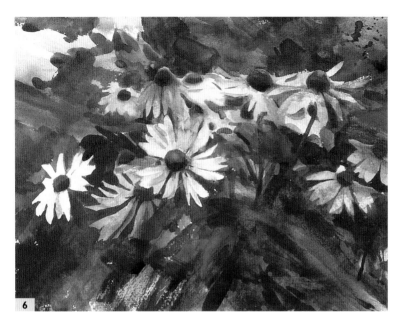

Step Six To maintain the attention on the flowers, I keep the forms of the green leaves simple and abstract. In context, the viewer will see the green splatters as leafy vegetation. Deciding that the small flower above the main group in the center is distracting, I use a medium flat bristle brush and paint over the flower with the background colors (cobalt blue, alizarin crimson, and a bit of transparent oxide red). Then I use the small flat brush with the same mix of background colors to define the remaining flowers. Now that all the flowers are blocked in, I'm happy with the overall design.

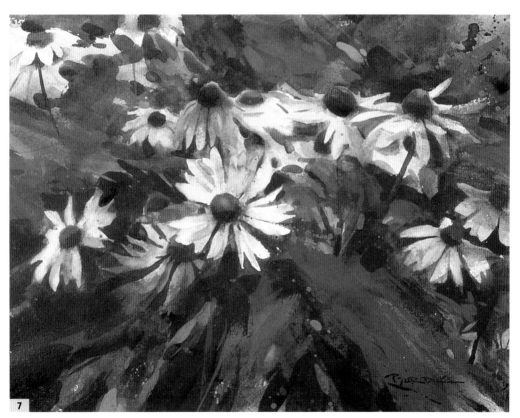

Step Seven Next I soften some of the petals' edges. For variety and added depth, I use a large filbert bristle to wash in sap green and transparent oxide red over the flower below and to the left of the main one. For the flowers in the upper left, I use minimal detail and almost geometric edges for even more variety. Finally I add some brighter color with a small watercolor brush and pure cobalt blue and cobalt violet, as well as cadmium orange with yellow ochre and white.

63

Conclusion

If you are new to plein air painting, try not to be discouraged if your initial paintings are not everything you hope for! Even after years of study in art school, when I first began camping and painting outdoors, I felt as if everything I had learned had gone right out the window. It's easy to become overwhelmed with the unfamiliar equipment, the wind, the bugs, and the moving clouds and light. But don't give up! Only by getting out there and continuing to paint will you become more comfortable with the exhilarating world of painting *en plein air*. When things do start to go right, working "on the spot" in some of the most beautiful places in the world is simply amazing. I can honestly say that my fondest memories as an artist are all of painting outdoors. So keep experimenting with new techniques and different subject matter, and enjoy your experiences painting outdoors!

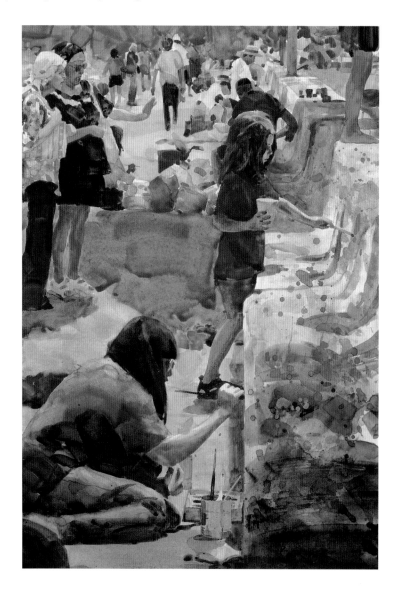